The Timeless
SEASHORE

JOSEPH R. VOTANO

4880 Lower Valley Road · Atglen, PA 19310

Other Schiffer Books by Joseph R. Votano:

The Ever-Changing Coastline: Tidal Forces at Work,
ISBN 978-0-7643-5487-8

Other Schiffer Books on Related Subjects:
The Cape Cod National Seashore, Christopher Seufert,
ISBN 978-0-7643-3995-0

Lighthouses and Coastal Attractions of Southern New England,
Allen Wood, ISBN 978-0-7643-5245-4

Lighthouses and Coastal Attractions of Northern New England,
Allen Wood, ISBN 978-0-7643-5235-5

"Schiffer," "Schiffer Publishing, Ltd.," and the pen
and inkwell logo are registered trademarks of Schiffer
Publishing, Ltd.

Designed by Brenda McCallum
Type set in Aldine/Bernhard Tango
ISBN: 978-0-7643-5488-5
Printed in China

Published by Schiffer Publishing, Ltd.
4880 Lower Valley Road | Atglen, PA 19310
Phone: (610) 593-1777; Fax: (610) 593-2002
E-mail: Info@schifferbooks.com
Web: www.schifferbooks.com

For our complete selection of fine books on this and related
subjects, please visit our website at www.schifferbooks.com.
You may also write for a free catalog.

Schiffer Publishing's titles are available at special discounts
for bulk purchases for sales promotions or premiums.
Special editions, including personalized covers, corporate
imprints, and excerpts, can be created in large quantities for
special needs. For more information, contact the publisher.

We are always looking for people to write books on new
and related subjects. If you have an idea for a book, please
contact us at proposals@schifferbooks.com.

The Timeless
SEASHORE

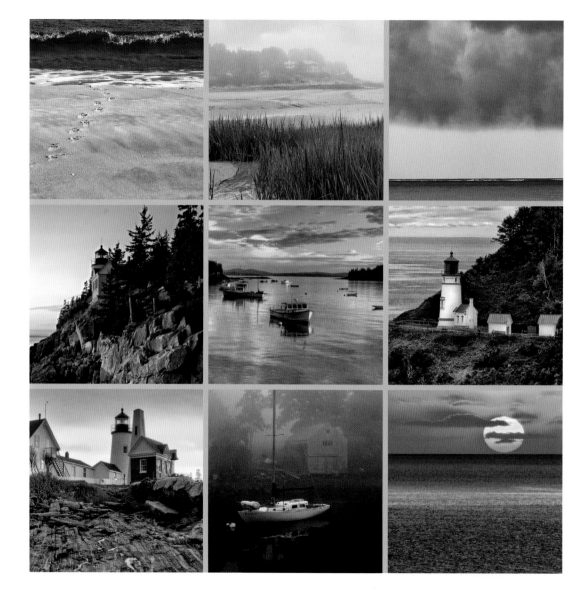

CONTENTS

Acknowledgments

I'd like to thank the designers and editors at Schiffer Publishing for their work on this book, as well as Karen Hosking, Karl Schanz, Ken Jordan, and Robert Lamacq, who contributed various images. Most of all, thank you to my wife, Gail, whose patience and support made this book possible.

INTRODUCTION

Nothing in nature is more dynamic than the seashore, with its endless tides, shifting sands, ocean currents, and the sound of waves rhythmically washing the shore. Anyone who has spent time by the ocean never forgets its infinite expanse and the sense of solitude and relaxation it brings. Tidal forces, a result of the sun and moon's gravitational pull, create mysterious landforms such as cliffs, chasms, sea stacks, and sandbars. Man, too, has left his mark on the seashore with harbors, piers, boats, dwellings, and lighthouses.

The joy of being at the seashore is a lasting memory for most of us. Forty percent of the world's population (approximately 2.9 billion people) live within thirty-seven miles (sixty km) of the sea, and roughly half the world's populations derive food sources from the oceans.

This book depicting the United States's eastern and western shorelines explores beaches and sea stacks and, by association, the sand dunes and grasses that help stabilize shorelines. Rocky coasts and inlets are especially breathtaking along the New England coast from Maine to Massachusetts and out West in Oregon and Washington. These images reveal the diversity of rocky landforms. Harbors and inlets dot the coastlines of Maine and Massachusetts, providing a window into how people make their living from the sea.

This book also explores many different forms of East Coast lighthouses from Maine to St. Augustine, Florida, and elsewhere—all of them on the National Registry of Historic Places. The next chapter captures surprising seashore finds—something every avid beach stroller has experienced. Fog is a regular and mysterious visitor to the coasts—there is always a question of what lies beyond it. Finally, we will explore sunsets and moon rises over Cape Cod Bay in Massachusetts, Monhegan Island in Maine, and along the Oregon coast. The scenery is as varied and timeless as the sea itself.

BEACHES, TIDES & SEA STACKS

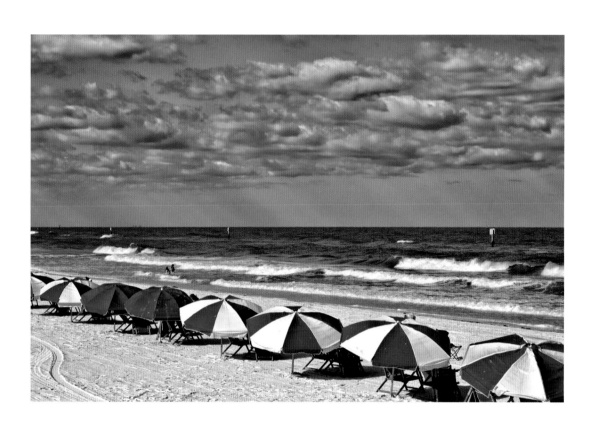

PLATE | 1 |

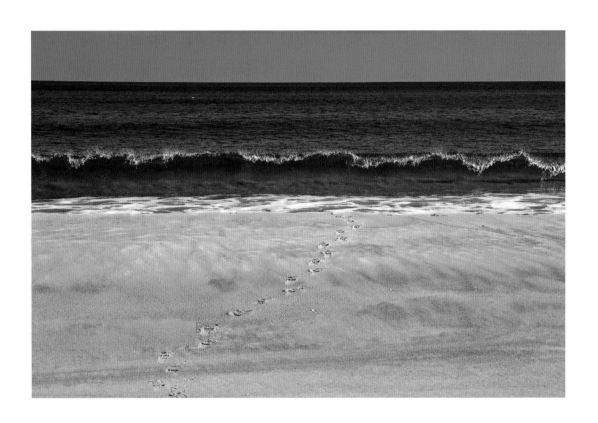

PLATE | 2 |

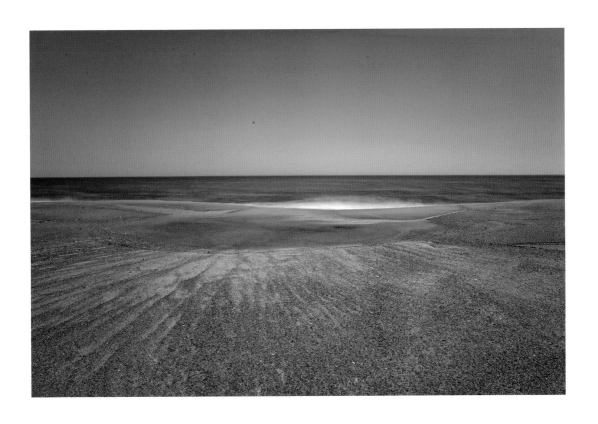

PLATE | 3 |

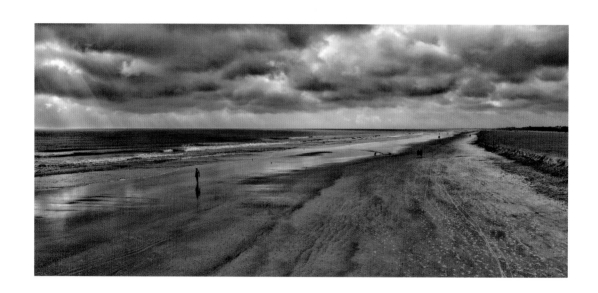

PLATE | 4 |

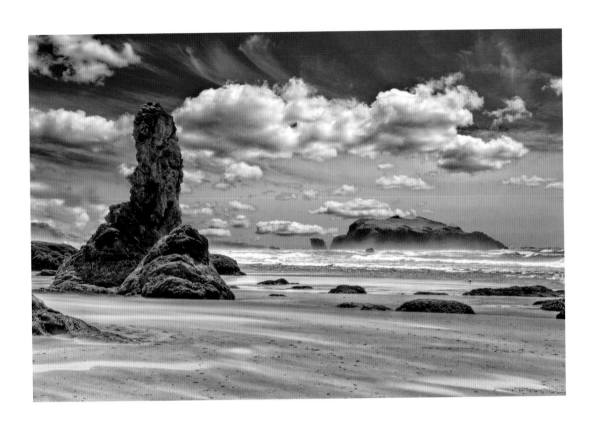

PLATE | 5 |

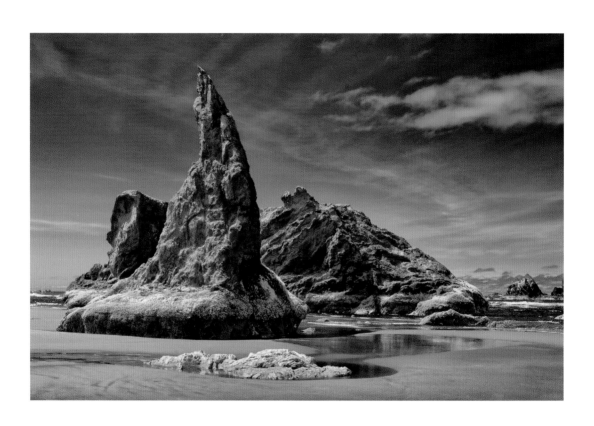

PLATE | 6 |

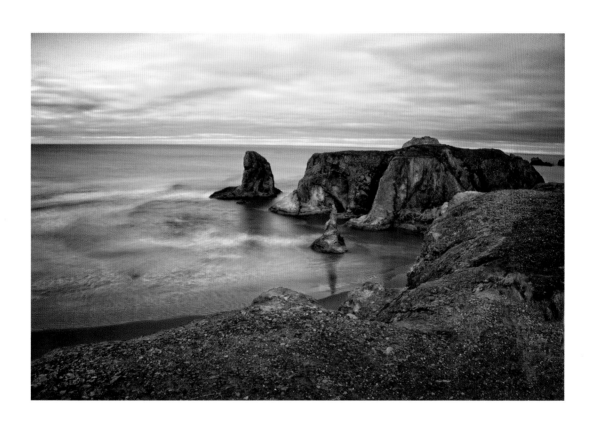

PLATE | 7 |

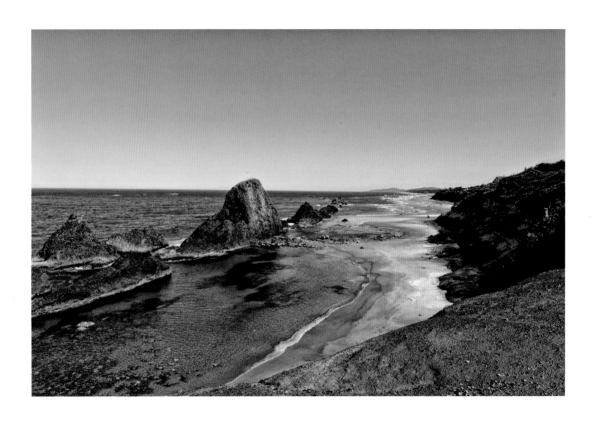

PLATE | 8 |

COASTAL DUNES
& GRASSES

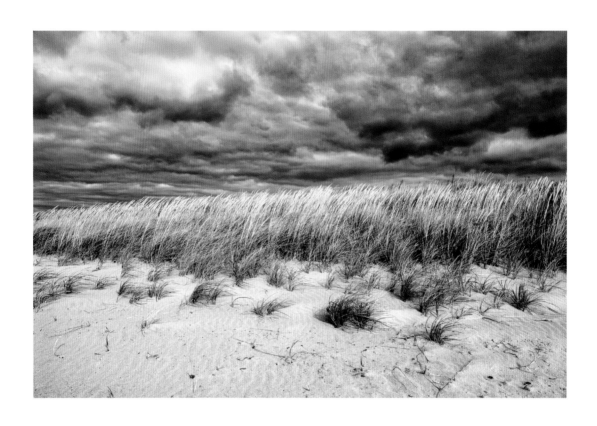

PLATE | 9 |

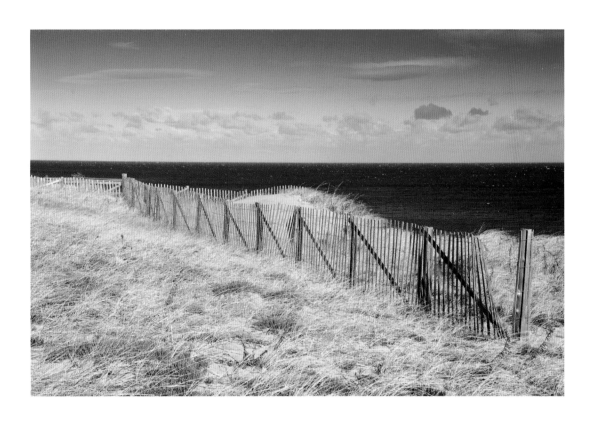

PLATE | 10 |

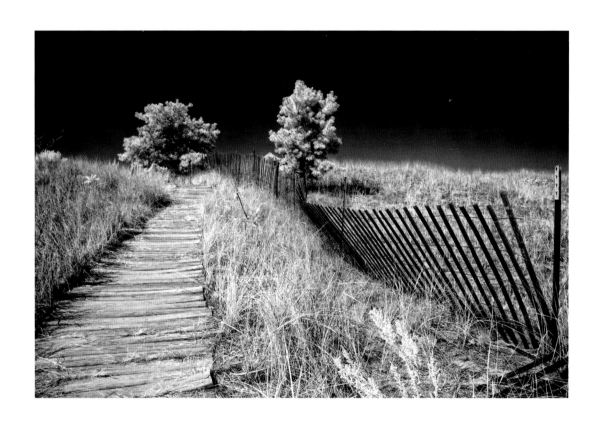

PLATE | 11 |

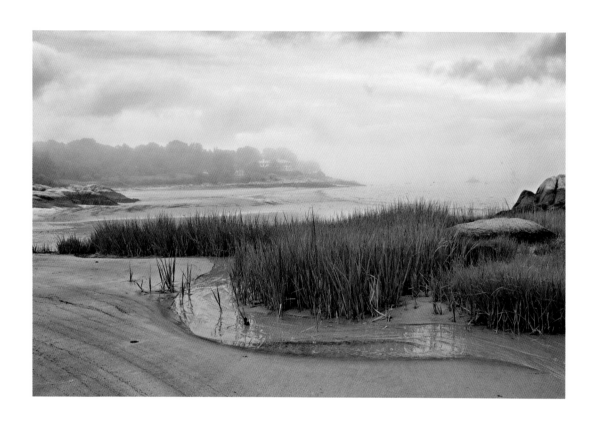

PLATE | 12 |

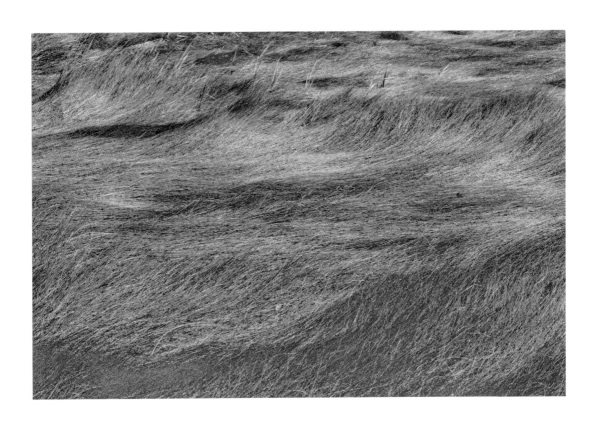

PLATE | 13 |

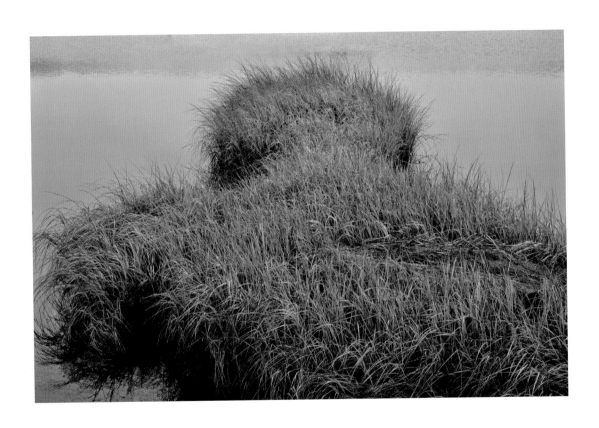

PLATE | 14 |

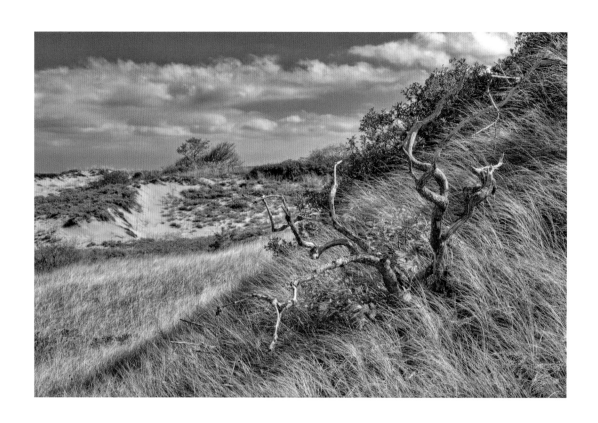

PLATE | 15 |

SEASHORE ARTISTRY

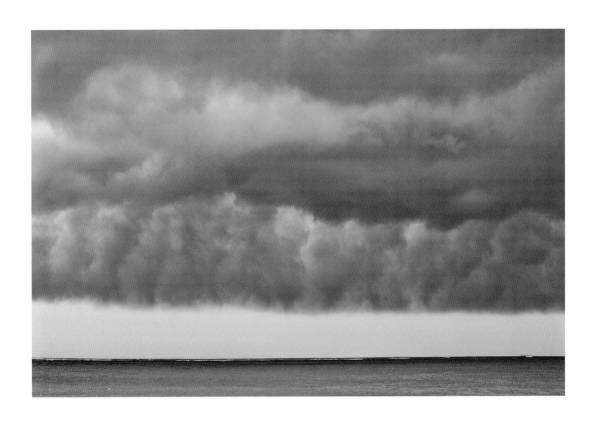

PLATE | 16 |

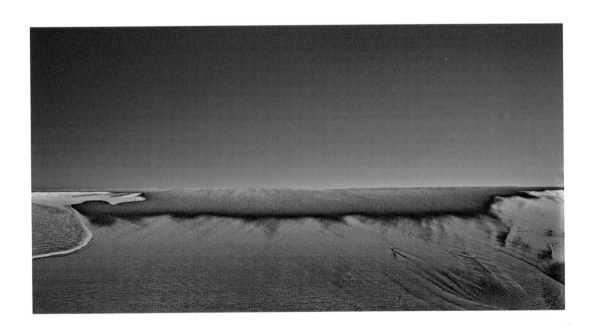

PLATE | 17 |

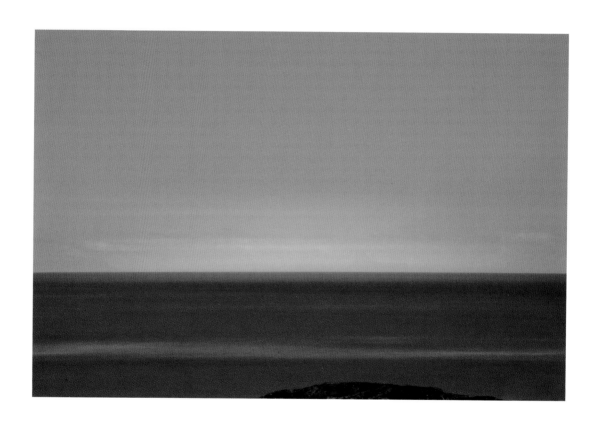

PLATE | 18 |

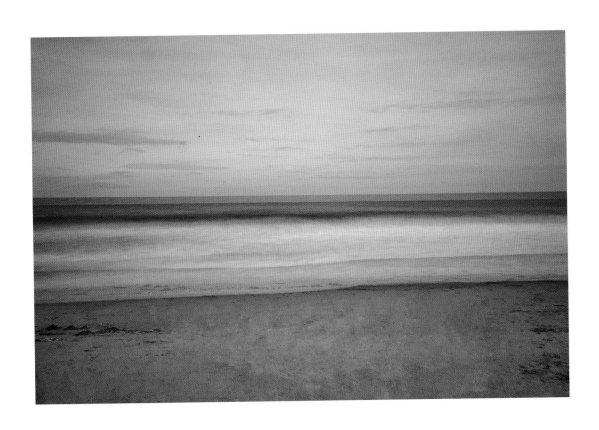

PLATE | 19 |

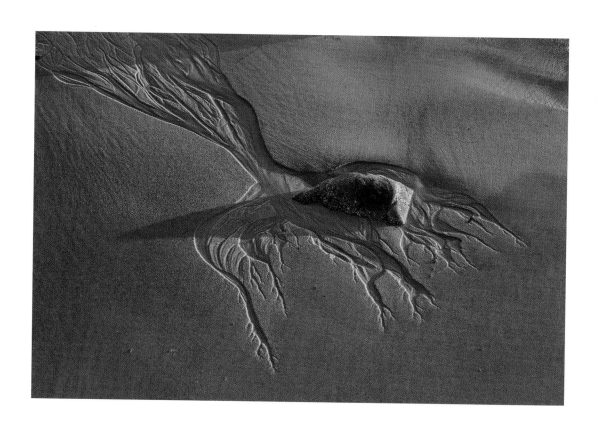

PLATE | 20 |

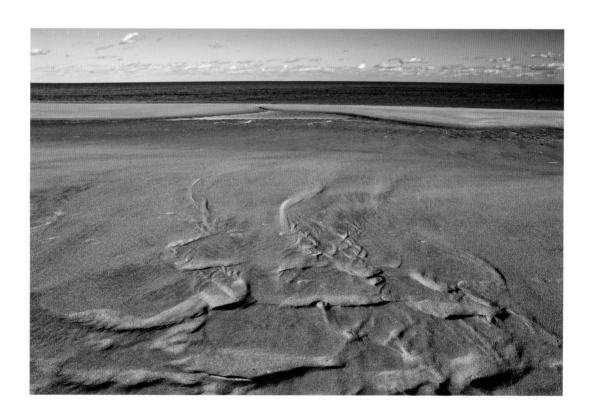

PLATE | 21 |

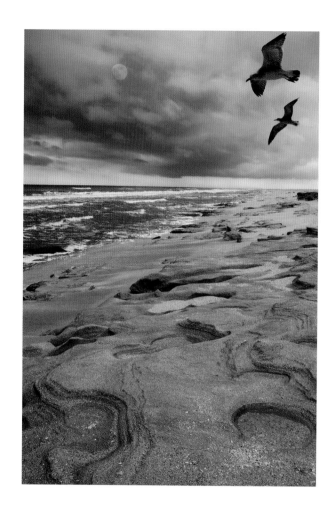

PLATE | 22 |

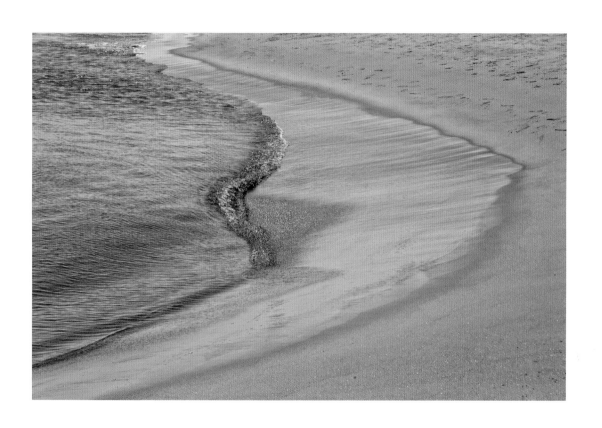

PLATE | 23 |

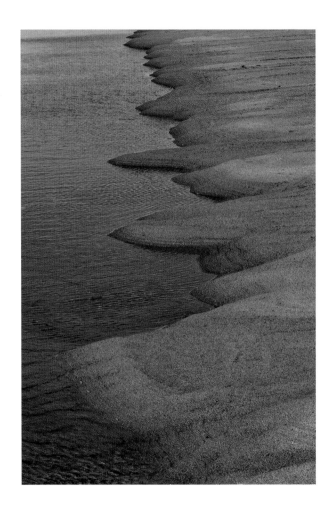

PLATE | 24 |

ROCKY SEASHORES
& CLIFFS

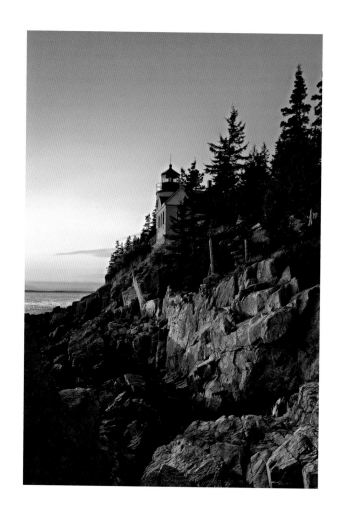

PLATE | 25 |

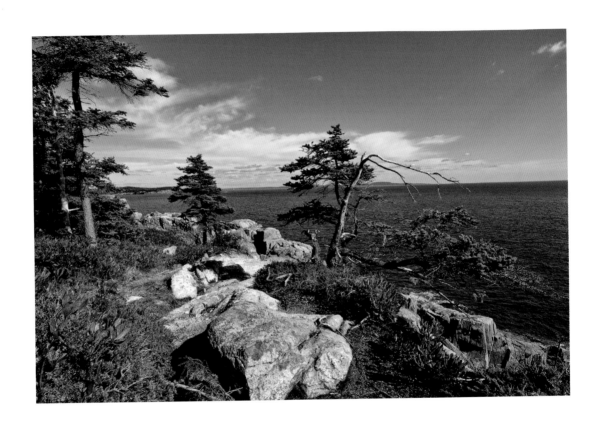

PLATE | 26 |

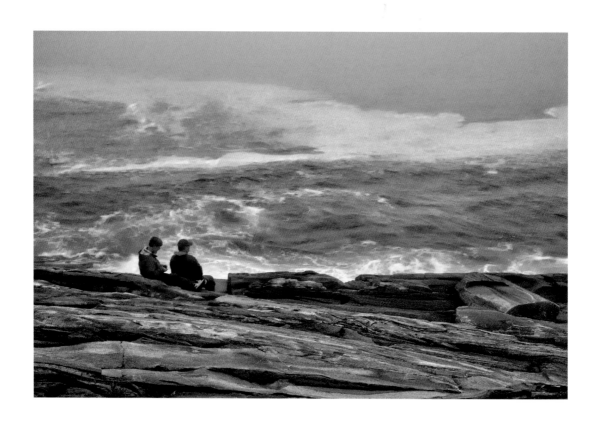

PLATE | 27 |

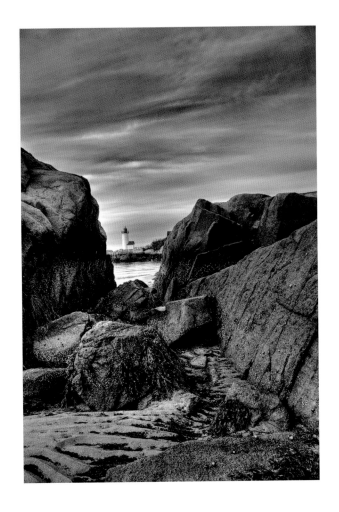

PLATE | 28 |

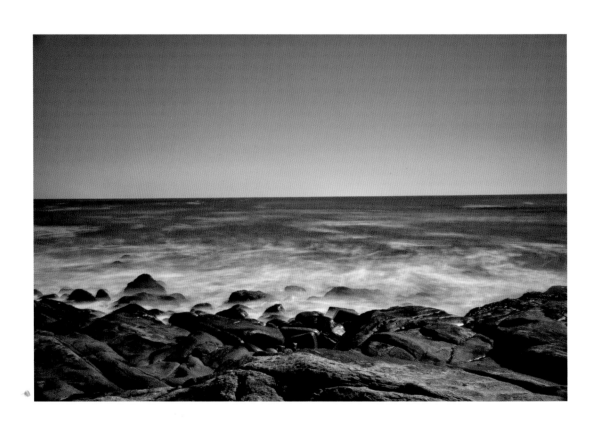

PLATE | 29 |

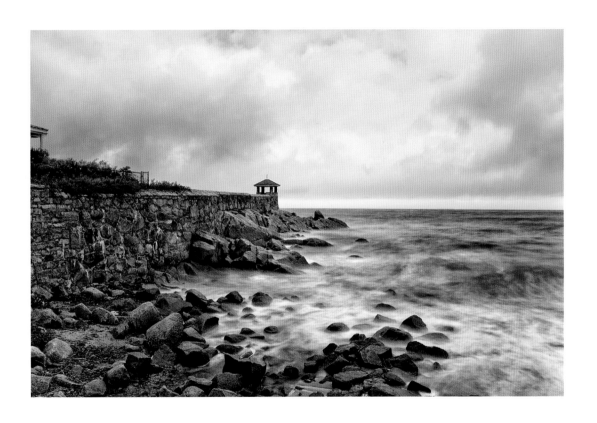

PLATE | 30 |

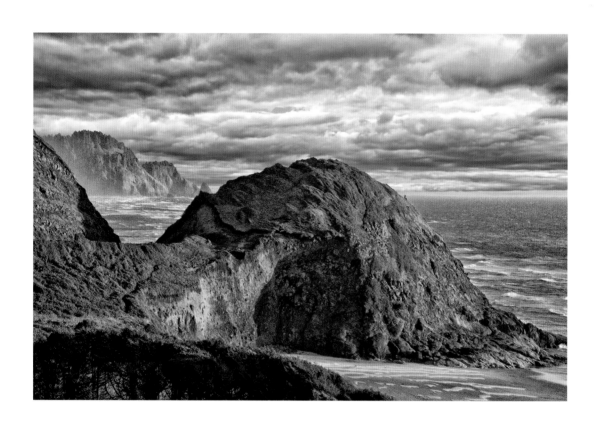

PLATE | 31 |

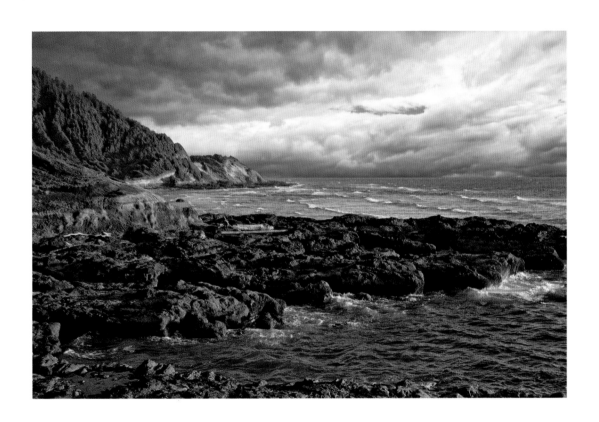

PLATE | 32 |

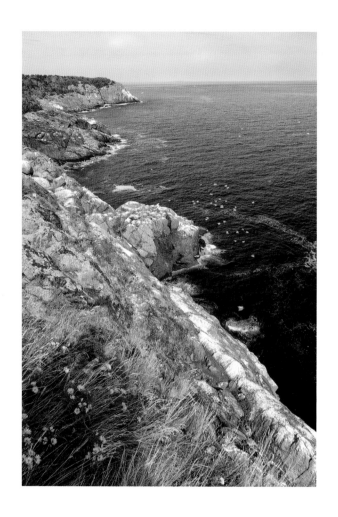

PLATE | 33 |

COASTAL INLETS

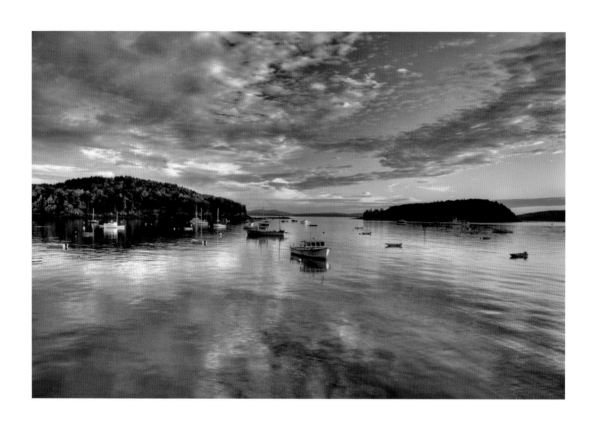

PLATE | 34 |

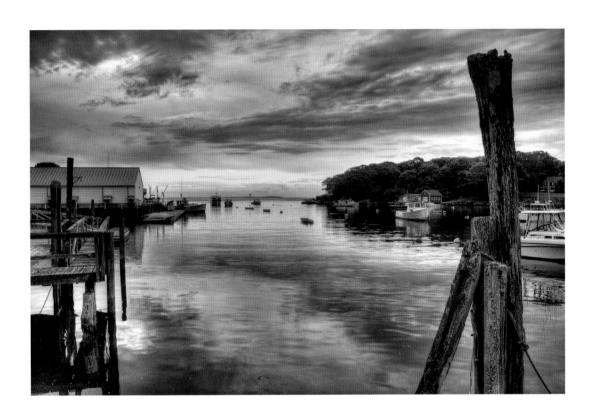

PLATE | 35 |

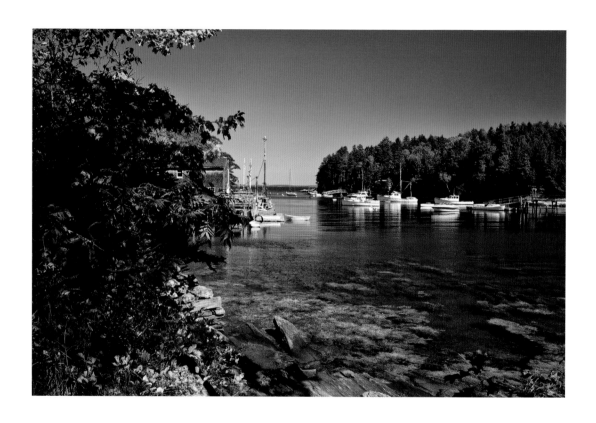

PLATE | 36 |

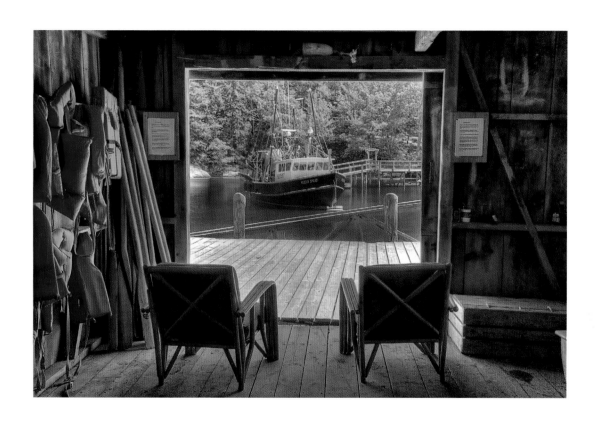

PLATE | 37 |

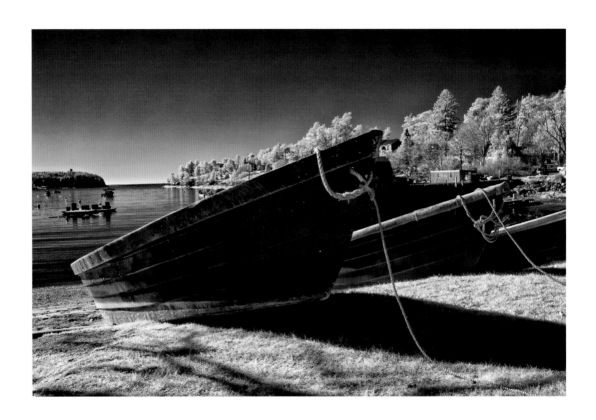

PLATE | 38 |

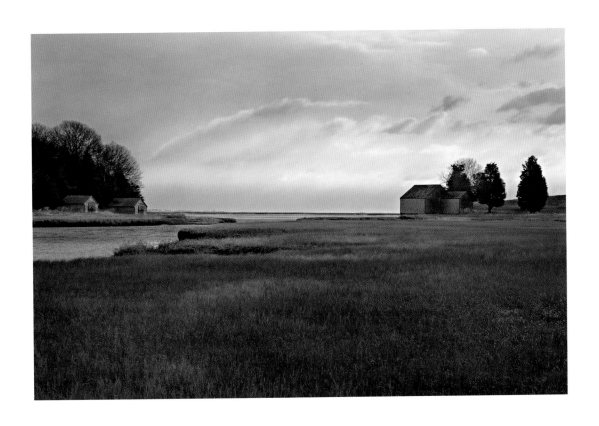

PLATE | 39 |

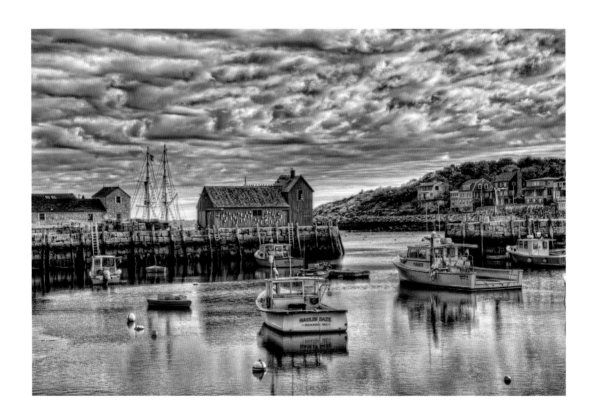

PLATE | 40 |

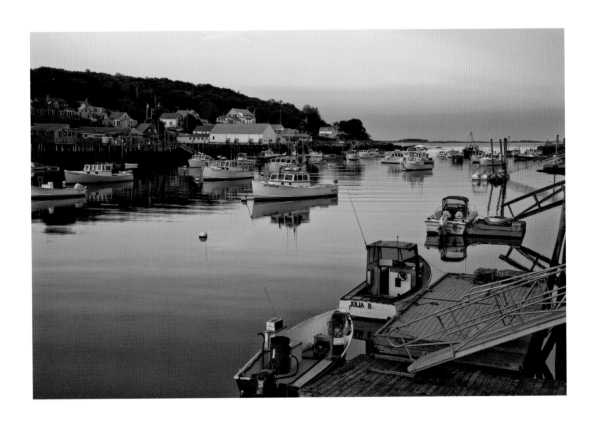

PLATE | 41 |

LIGHTHOUSES,
THE SEASHORE SENTINELS

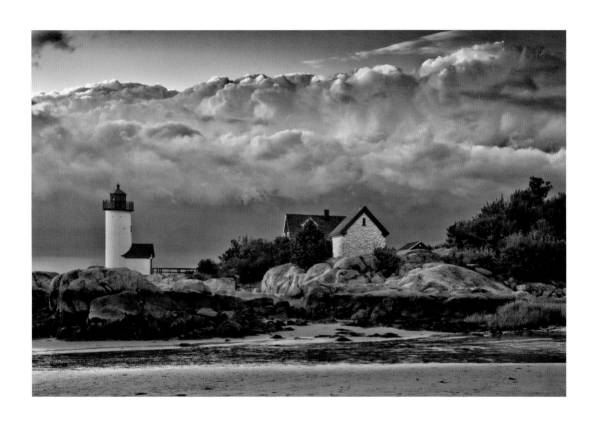

PLATE | 42 |

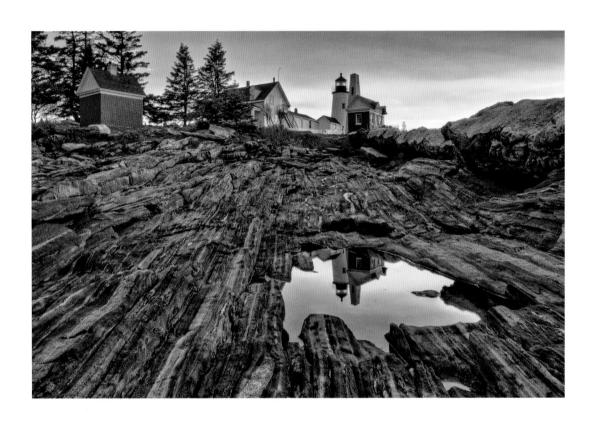

PLATE | 43 |

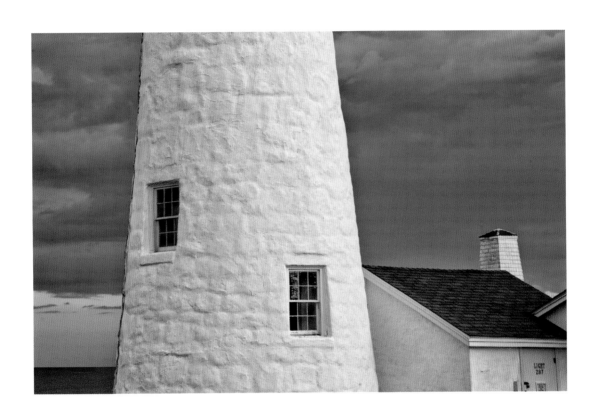

PLATE | 44 |

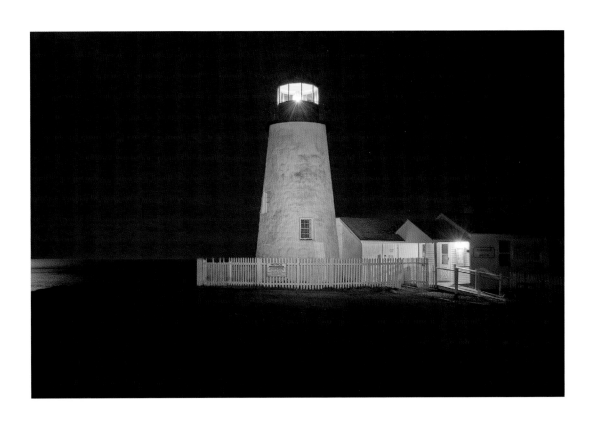

PLATE | 45 |

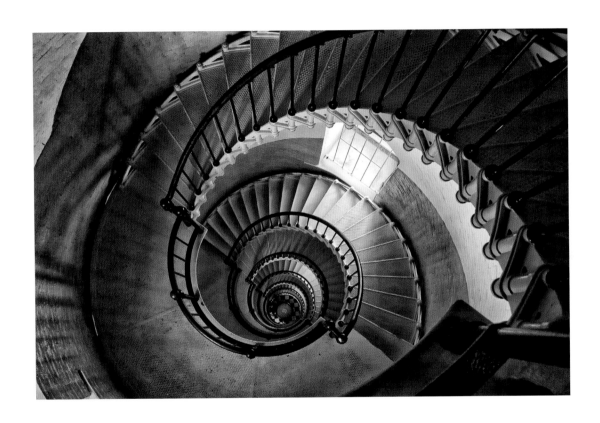

PLATE | 46 |

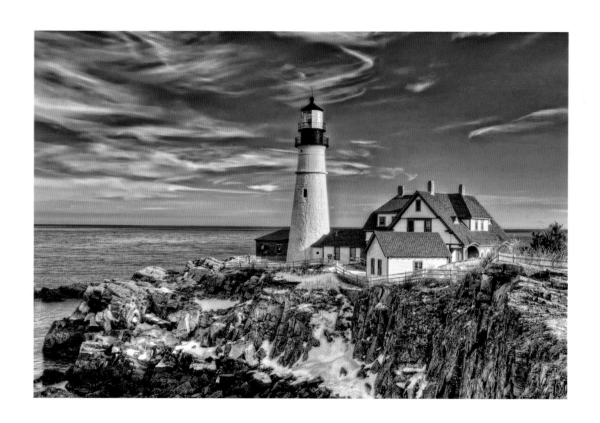

PLATE | 47 |

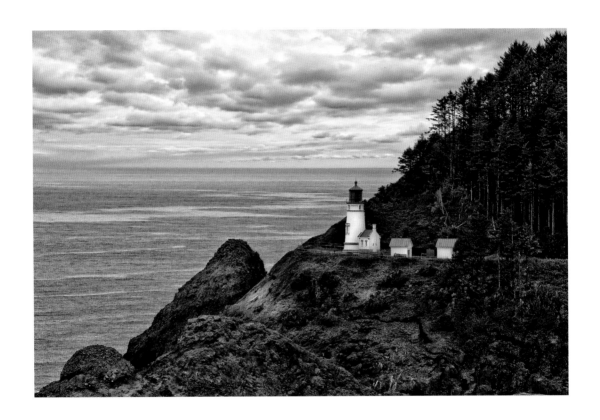

PLATE | 48 |

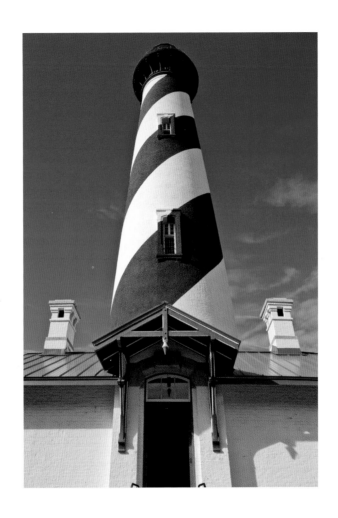

PLATE | 49 |

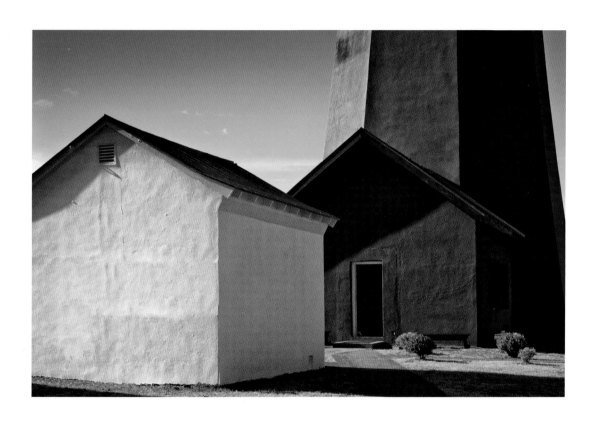

PLATE | 50 |

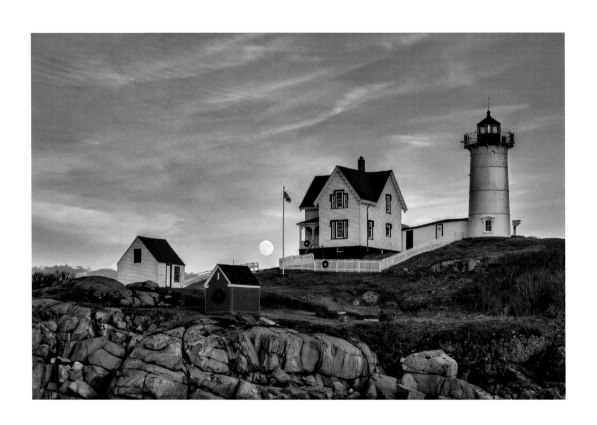

PLATE | 51 |

SEASHORE FINDS

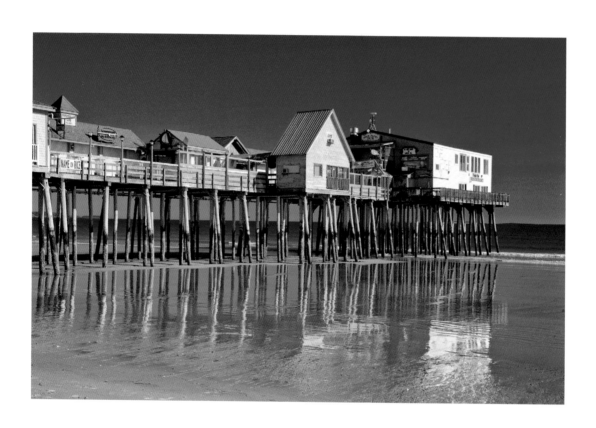

PLATE | 52 |

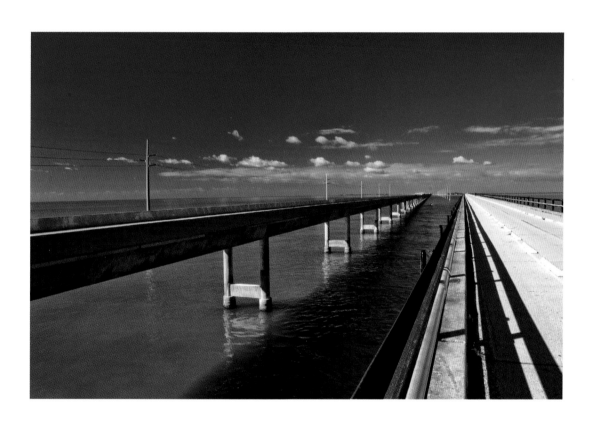

PLATE | 53 |

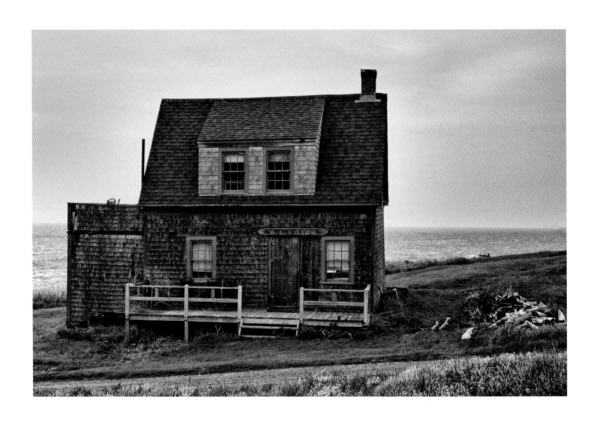

PLATE | 54 |

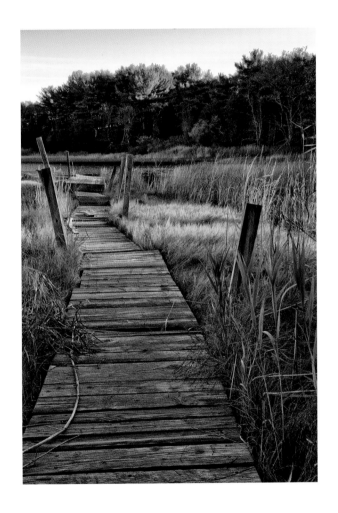

PLATE | 55 |

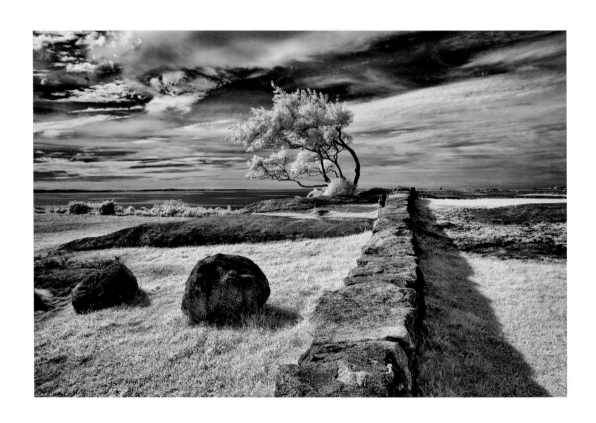

PLATE | 56 |

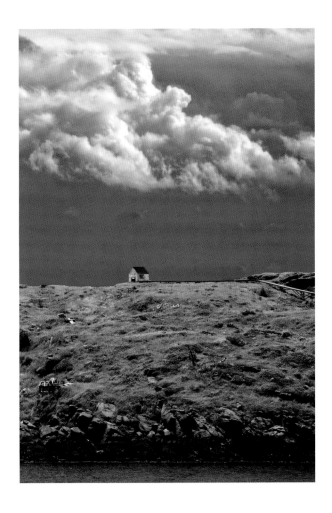

PLATE | 57 |

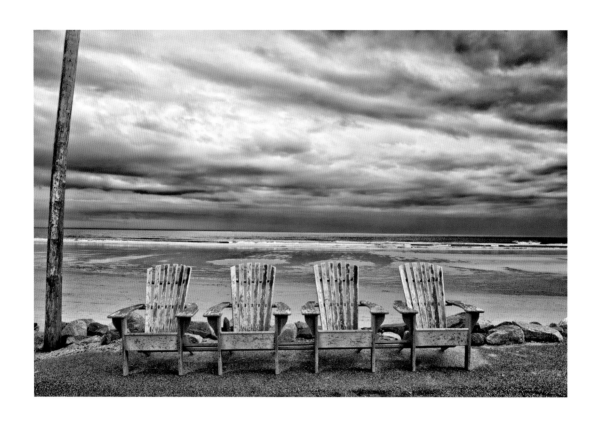

PLATE | 58 |

FOGGY DAYS

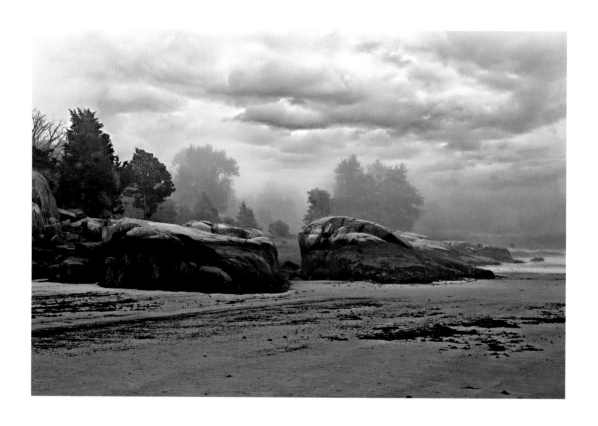

PLATE | 59 |

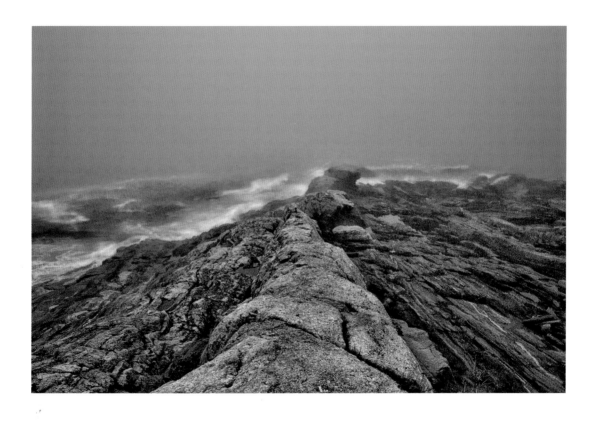

PLATE | 60 |

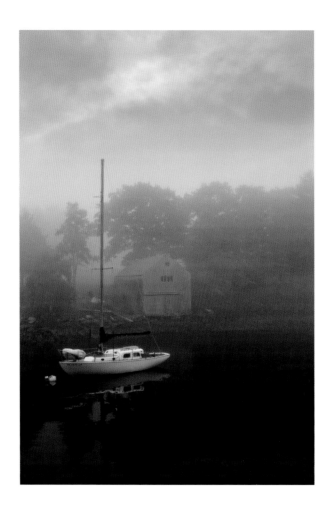

PLATE | 61 |

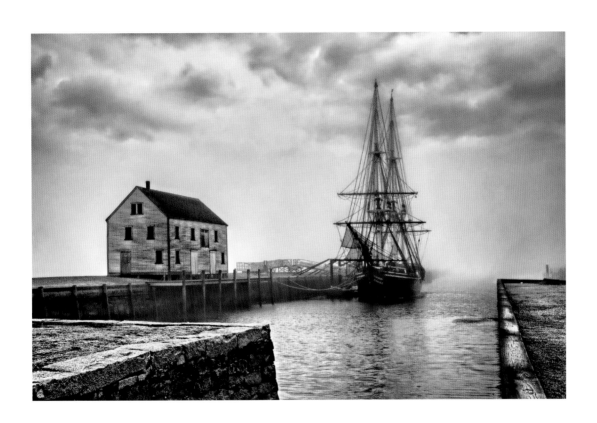

PLATE | 62 |

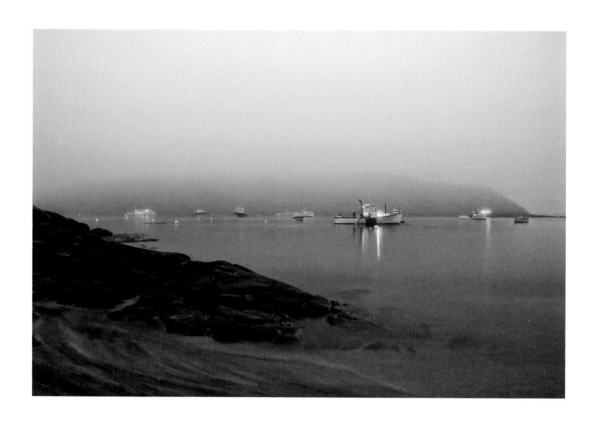

PLATE | 63 |

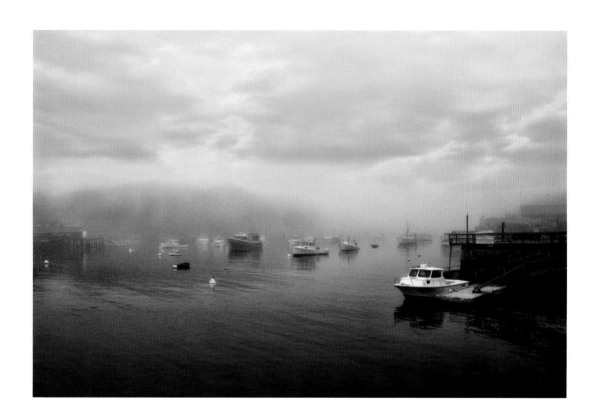

PLATE | 64 |

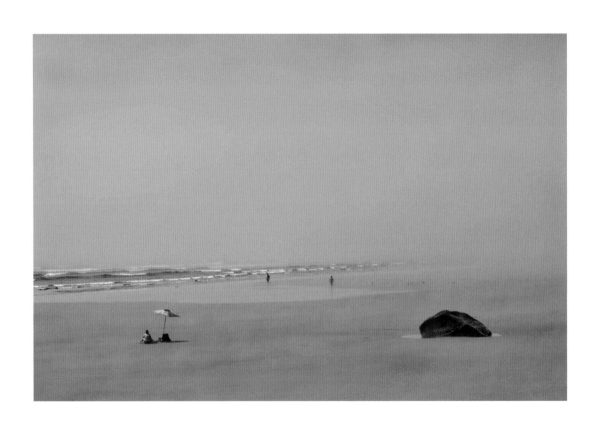

PLATE | 65 |

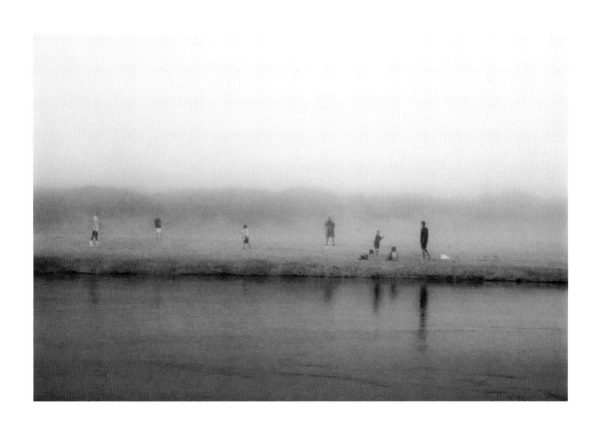

PLATE | 66 |

SUNRISE, SUNSET & MOON OVER THE BAY

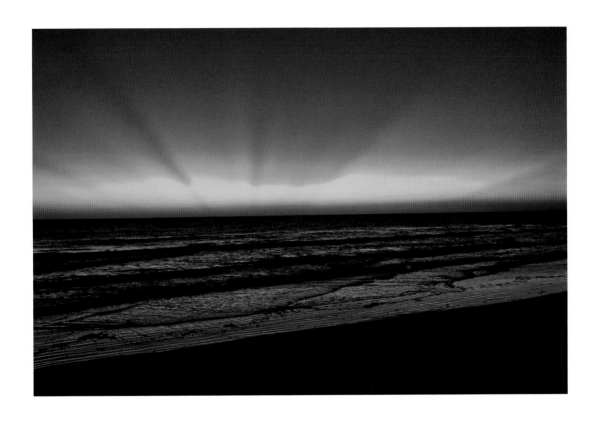

PLATE | 67 |

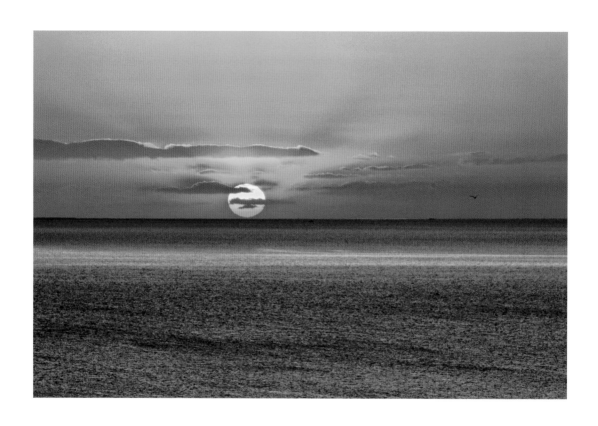

PLATE | 68 |

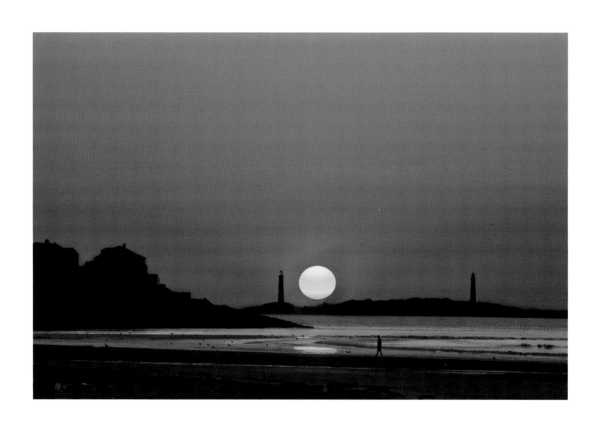

PLATE | 69 |

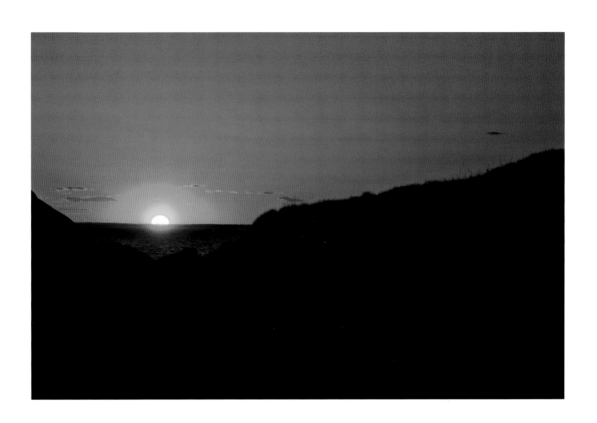

PLATE | 70 |

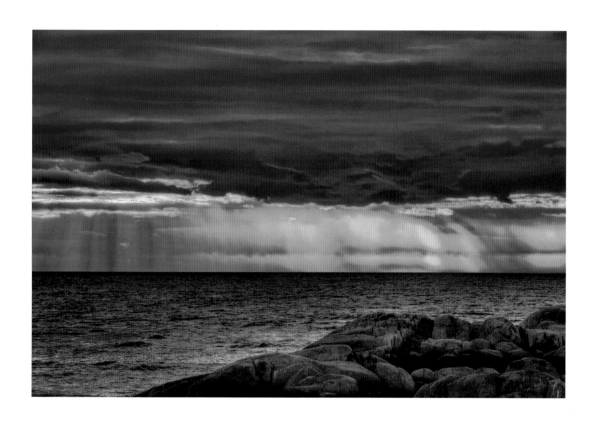

PLATE | 71 |

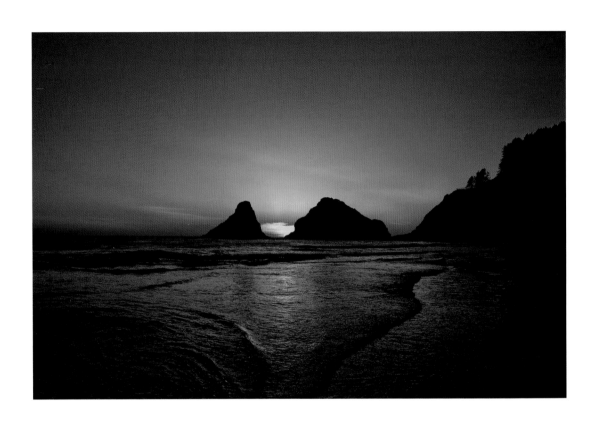

PLATE | 72 |

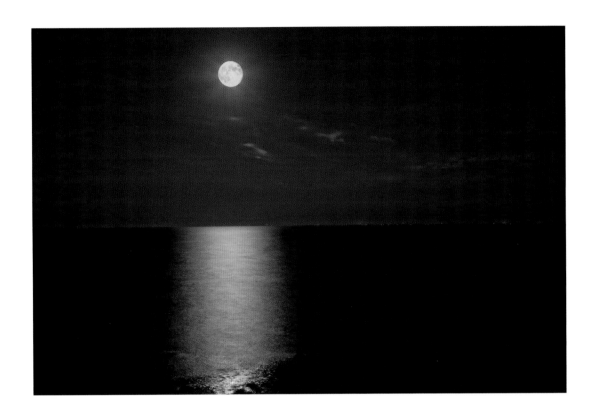

PLATE | 73 |

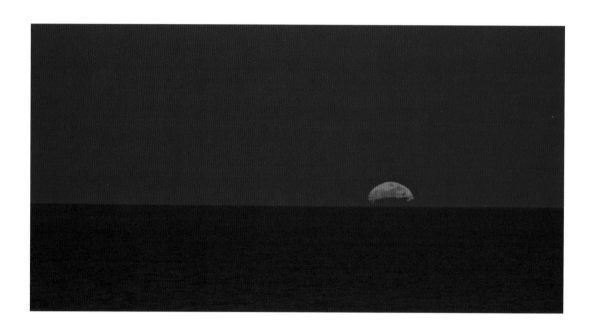

PLATE | 74 |

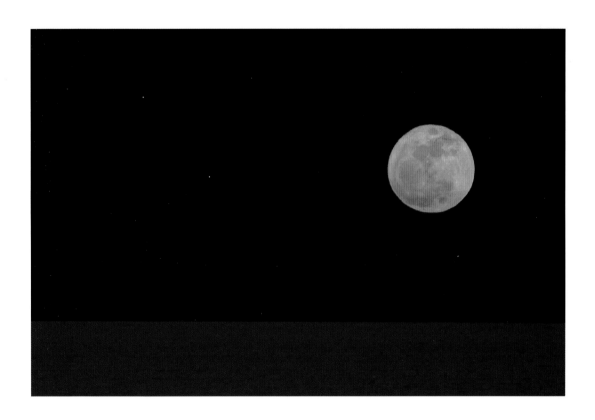

PLATE | 75 |

Photographers

J.R.V. - Joseph R. Votano
K.H. - Karen Hosking
K.S. - Karl Schanz
K.J. - Ken Jordan
R.L. - Robert Lamacq

INDEX OF LOCATIONS

About the author

Joseph Votano is a photographer whose published works include travelogues of Europe, Boston, and Cape Cod, as well as *Boston Below* and *Shaker Legacies*, both published by Schiffer Publishing. His images have appeared in *Prestige Travel Hong Kong*, Michelin travel guides, *Aishti* magazine (Middle East), and Boston.com. Some of his work can be seen on his website, www.joevotanophotography.com.

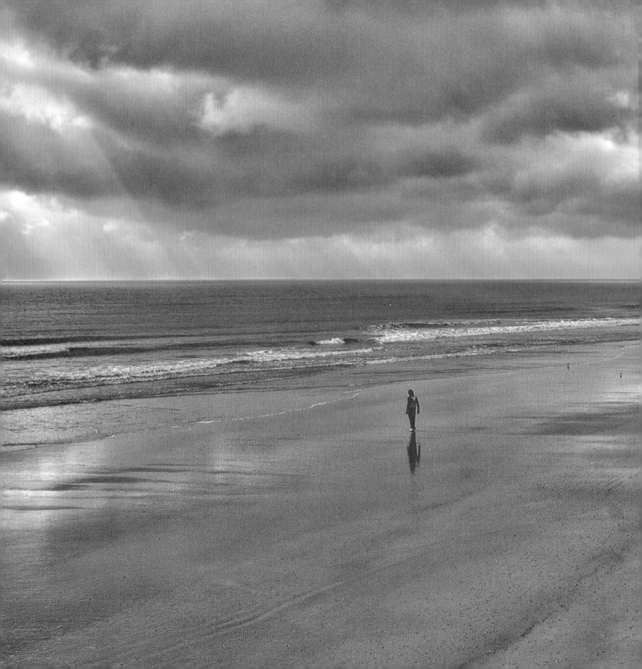